L'Amour

Politique

A Collection of Poetry by

Lo Potter

Copyright 2021 by Lo Potter

www.lopotterwrites.com

Contact: lopotterwrites@gmail.com

Photography by Lo Potter

ISBN:
978-1-63877-889-9 (Hardcover)
978-1-63877-877-5 (Paperback)

First Edition

Political • Identity

(adj) /pəˈlidək(ə)l/ • (n) /ˌīˈden(t)ədē/

The aspect of one's being relating to, affecting, or acting according to the interests of status or authority within an organization rather than matters of principle. How one relates to authority, society, and relationships. An aspect of personality determined from a young age. A pain in my father's ass, as is the family tradition.

-Lo Potter

In Dedication

To my family,

Without those who support you from the beginning it is hard to know who you are in the end.

Thank you for everything.

A Note To Readers:

The following collection of poems contains references to life changing experiences, internal and external, that may provoke a strong reaction in some individuals with experience in emergency medicine, law enforcement, search and rescue, disaster relief aid, and other similar fields. A selection of poems are directly influenced by lived, traumatic work experiences. Reader discretion is advised.

I watch a woman melt today

Skin sags off a decomposing body

With a sputtering heart

Interstitial fluid melts into

The heated inflated bed

Brain death at 4 o'clock in the afternoon

Her children bicker in the hallway

Her pacemaker trips

Every few minutes

They sign away their rights to sue

Hospital-Acquired Infection List Marathon

As the ventilator sings positive pressure

"So she never woke up from the surgery?"

"No," the doctor lies

Through his military smile

I am a phlebotomist and

A disease controller:

Biohazard level 4 room, Sir

Check-in Check-out - a list procedure

[Can't talk back to the M.D. - Report her!]

I keep my mouth shut

As they beg for hope

Their mother's dripping on the floor

More Chux! More Chux!

But their sister has to get there

Before they allow us

To turn off the machines.

Juin 2013

Je regarde une femme fondre aujourd'hui

La peau affaissée de son corps en décomposition

Avec un cœur en difficulté

Le liquide interstitiel se fond dans

Le lit gonflable chauffé

Mort cérébrale à 16 h

Ses enfants se chamaillent dans le couloir

Le stimulateur cardiaque s'active

Toutes les quelques minutes

Ils renoncent à leurs droits de poursuivre

Un marathon d'infections nosocomiales

Lorsque le ventilateur chante une pression positive

«Alors elle ne s'est jamais réveillée de la chirurgie?»

«Non» ment le docteu

À travers son sourire militaire

Je suis phlébotomiste et

Un contrôleur de la maladie:

Chambre niveau 4 Biohazard, Sir

Check-in Check-out - une procédure de liste

«Ne contestez pas le M.D. - Signalez-la!»

Je garde la bouche fermée

Alors qu'ils crient d'espoir

Leur mère fond au sol

Plus de alèses! Plus de alèses!

Mais leur sœur doit y arriver

Avant qu'ils nous quittent

Pour éteindre les machines.

A Moment Aflame

at tables cleaned and polished by our own hands we sit
attempting personal renaissance:
a moment in time caught fire.
we sit, write, talk, eat, drink, breathe in-
to creation
 the desperation
for a life out –
side of this very existence
controlled by desire to satiate the disease of purpose
symptoms driven deep into young minds by
careless words;
unanswered questions:
unfulfilled dreams pushed onto another generation
as lost grown children wander with empty eyes and
imploding hearts.

they told us we were equal,
instead,
we are searching for explanations –
why this world has treated our existences like matches:
struck aflame
burned out
thrown away

Un Moment En Feu

aux tables nettoyées et polies de nos propres mains, nous asseyons

tentative de renaissance personnelle:

un moment dans le temps a pris feu.

nous nous asseyons, écrivons, parlons, mangeons, buvons,

respirons

A la création

 le désespoir

pour une vie–

côté de cette existence même

contrôlé par le désir de satisfaire la maladie qui est le but

symptômes profondément ancrés dans les jeunes esprits

mots imprudents;

questions sans réponse:

rêves non réalisés poussés à une autre génération

alors que des enfants adultes perdus errent les yeux vides et les

cœurs implosés.

ils nous ont dit que nous étions égaux,

au lieu,

nous cherchons des explications –

pourquoi ce monde a traité nos vies comme des allumettes:

a pris feu

brûlé

jeté

The Corpus of Jane Doe

A mountain of paperwork

Encumbers my day

In the mortuary she waits-

Chalk-white and purple

Coagulated blood at the points

We knew to be the lowest

Where she laid waiting to be found

She is your typical body.
No tattoos or piercings
Barely more information than:
Hair, Eyes, Skin, Size

What is the immutable?

She had an identity with a past:
Information trapped behind
Unmoving lips and rigor mortis
Lost to the depths of an unseen mind

Someone loved this woman:
Her vibrant smile I never see
How her cheeks flushed
At compliments or with tears

We gather information
-what we objectively know-
To approximate backward
Into a time before death
Where parents held a baby
And gave her a name

Le Corpus de Jane Doe

Une montagne de paperasse

Pèse ma journée

Dans la morgue, elle attend-

Craie-blanc et violet

Sang coagulé aux points

Nous savions étions les plus bas

Où elle était allongée en attendant d'être trouvée

Elle est votre corps typique.

Pas de tatouages ni de piercings

Un peu plus d'informations que:

Cheveux, yeux, peau, taille

Qu'est-ce que l'immuable?

Elle avait une identité avec un passé:

Informations piégées derrière

Lèvres immobiles et rigor mortis

Perdu dans les profondeurs d'un esprit invisible

Quelqu'un a adoré cette femme:

Son sourire vibrant que je ne vois jamais

Comment ses joues sont devenues rouges

Aux compliments ou aux larmes

Nous collectons des informations

-ce que nous savons objectivement-

Rapprochez-vous

Dans un temps avant la mort

Où les parents tenaient un bébé

Et lui a donné un nom

We Are Nothing

we are nothing, but nothing –
razor-edged souls cutting through time
with a steely gasp of twilight before our instant sunset,
packaged in a plastic microwavable container with a label
stating,
"just add water"
we, a single individual with many minds and parts -
societal schizophrenia on a rampage.
perhaps the voice of muscle spasm can sear through your
tyranny,
as you have trapped creativity and youth in oppression,
tearing them from their families
as though they were meant to be institutionalized with
bars on the windows and
locks on the doors.
keep faith, children!
for there is always an alternative route grasping for a mind that
could fathom his existence.
outside the window is a world darkened by a starless reality,
yet lit by polluting city lights.
Red, Green, Blue
straining for that chance to say, "Coca-Cola" in Times Square.
But this –
this is nothing.

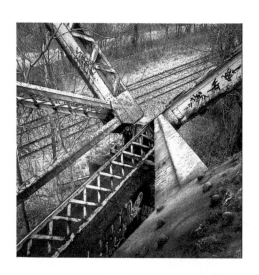

Nous Ne Sommes Rien

nous ne sommes rien, mais rien –

des âmes aiguisées qui traversent le temps

avec un soupir crépusculaire avant notre nuit soudaine,

emballé dans un récipient en plastique allant au micro-ondes avec une

étiquette indiquant,

«Il suffit d'ajouter de l'eau»

nous, un individu avec de nombreux esprits et parties -

la schizophrénie sociale incontrôlable.

peut-être que la voix du spasme musculaire peut brûler votre tyrannie,

comme vous avez piégé la créativité et la jeunesse dans l'oppression,

les arrachant à leurs familles

comme s'ils étaient censés être institutionnalisés avec

barres sur les fenêtres et

serrures sur les portes.

gardez la foi, les enfants!

parce qu'il y a toujours une manière alternative de saisir un esprit qui

pourrait comprendre son existence.

derrière la fenêtre se trouve un monde obscurci par une réalité sans

étoiles,

pourtant éclairé par les lumières de la ville polluantes.

Rouge, Vert, Bleu

luttant pour cette chance de dire «Coca-Cola» à Times Square.

Mais ça – ce n'est rien.

Exoskeletons

Before you, there was simply the
thing that became you
That perfectly valid piece of personal history
that we all must shed as
Exoskeletons of youth are the
constriction around
Wings of enlightenment

but these former selves are hard to break
Their brittle vulnerability: only
pieces crack off at a time.
Tortuously, joyously slow.

Exosquelette

Avant vous, il y avait simplement le

chose qui est devenue toi

Cette pièce d'histoire personnelle parfaitement valable

que nous devons tous jeter comme

Les exosquelettes des jeunesse sont les

constriction autour

Ailes de l'illumination

mais ces vieux moi sont difficiles à briser

Leur délicate vulnérabilité: seulement

les morceaux se fissurent à la fois.

Tortueusement, heureusement lentement.

Demiurge

The slow secretions that expel into our veins
Resolving to give us personality, perspective
The things that make us this "homo sapiens sapiens"
They turn on us with sharp glances:
Ex animate, self-loathing, vicious monster
The bane that creates us.
Turning thoughtfully
Under the glass cover of science
Dissected and revealed as though:
That is all that's there?

A more personal quandary,
Generations of galactic travels
Searching the starry skies
For the ecstasy of being reborn
Others - more obsessed with the macabre version
Searching for little more than an end
Something to rid the planet of
e.e. cummings's "man-unkind"

However, perhaps the answers we need

Are found more easily in a child's breath

Fogging up the train window as he stares

Into the eyes of people he may never see again

Writing his misunderstandings of sorrow

Backward to those who can't even read

Démiurge

Des sécrétions lentes qui traversent nos veines

Décidez de nous donner de la personnalité, de la perspective

Les choses qui font de nous cet «homo sapiens sapiens»

Ils se tournent vers nous avec des regards pointus:

Ex monstre vicieux animé, dégoût de soi

Le fléau qui nous crée.

Tourner pensivement

Sous le couvert du verre scientifique

Disséqué et révélé comme si:

Est-ce tout?

Un dilemme plus personnel,

Des générations de voyages galactiques

A la recherche du ciel étoilé

Pour que l'extase renaisse

Autres - plus obsédés par la version macabre

À la recherche d'un peu plus qu'une fin

Quelque chose pour débarrasser la planète

e.e. cummings est «man-unkind»

Cependant, peut-être que les réponses dont nous avons besoin

Se trouvent plus facilement dans l'haleine d'un enfant

Brumiser une fenêtre de train pendant qu'il regarde

Les yeux des gens qu'il ne reverra peut-être plus jamais

Alors qu'il écrit ses malentendus sur le chagrin

Apparaissant inversé à ceux qui ne savent même pas lire

A Study Of Masculinity

You take pedantic steps
That presence that follows everywhere
The waving hand that brushes hair
That well-tamed beard adorned across
Adonis face; perfect porcelain skin

Is this what you are? Such a perfect ceramic mask?
Or perhaps trapped within the statue?
If only you could cause a crack
Start a tremor; break down
With explosive flash: a man emerges stretching to the sky

He awakens! Lightning crashes to the earth
Eyes open to a world and such imperfection
With mallet and chisel, He seeks to correct
He creates new statues of men with what He learned
Desperate - He watches as worlds walk by

After He is dead and gone: a tremor, a crack, a little more
 To peel these creations out of their shells

Une étude de la masculinité

Tu fais des pas pédants

Cette présence qui suit partout

La main agitant brossant les cheveux

Cette barbe bien apprivoisée ornée

Le visage d'Adonis; peau de porcelaine parfaite

C'est ça que tu es? Un masque en céramique si parfait?

Ou peut-être piégé dans la statue?

Si seulement tu pouvais provoquer une fissure

Commencez un tremblement; panne

Avec flash explosif: un homme émerge en s'étirant vers le ciel

Il se réveille! La foudre frappe la terre

Les yeux ouverts sur un monde et une telle imperfection

Avec un maillet et un ciseau, il essaie de corriger

Il crée de nouvelles statues d'hommes avec ce qu'il a appris

Désespéré - Il regarde les mondes passer

Après qu'il est mort et parti: un tremblement, une fissure, encore plus

Faire naître ces créations de leurs coquilles

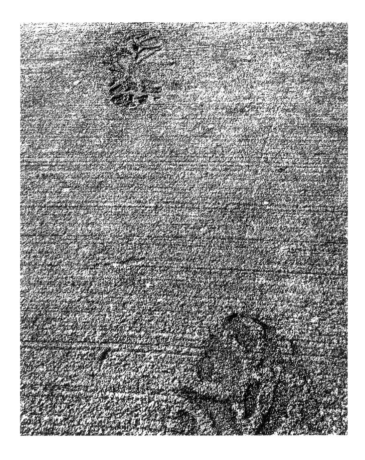

Emigrant

I'm tired in that way I don't want my children to be

of War
of Famine
of Life this way

I'm ready to find a safe place for their souls to germinate
As they blossom into adults that do not know
The struggles the farmer went through to sow

Émigrant

Je suis fatigué de cette façon je ne veux pas que mes enfants le
soient

de guerr
de la famine
de la vie de cette façon

Je suis prêt à trouver un endroit sûr pour que leurs âmes germent
Alors qu'ils s'épanouissent en adultes qui ne savent pas
Les luttes que le fermier a traversées pour les planter

American Cultured

Cultured like roadkill
On a hot summer's day
Driver by high speed
18 wheeler fly by
Accent rolling off tongues
Cleaner than a sailors
With the artificial faith
Of political bumper stickers
The cult of dental insurance
Filtering through Eisenhower's veins
With flashbulb cameras
And Hollywood trends
They choke on their implosion
Exposed maggots chewing away
The rotten insides
Of the country we mowed down
On our way to a National Park

Culture Américaine

Sophistiqué comme des animaux écrasés pourris

Par une chaude journée d'été

Pilotes haute vitesse

Sillage aérien de 18 roues

Accent roulant des langues

Plus propre qu'un marin

Avec la foi artificielle

Des autocollants pour pare-chocs politiques

Les cultes de l'assurance dentaire

Filtrer dans les veines d'Eisenhower

Avec des caméras flash

Et les tendances hollywoodiennes

Ils s'étouffent sous leurs implosions

Comme les asticots exposés rongent

L'intérieur pourri

Du pays que nous avons démoli

En route vers un parc national

Identity

Reflections of milky way jet-lagged,

summer-set childhood

exploding youth

that crept its lanky limbs along smiling lines of a carefree

face.

Stars in her eyes -

Ornamental explosions in the sky

While she sat among all that is good and innocent

As the sun burned

Candle of corruption yearned to take her,

Package her like instant rage

Hit the timer; pull the cord.

But no, not this one:

Time won't give you her.

Built with patient grass pillows, and willow tree songs,

mountains for teachers and flowers for books,

She will never own silver over glass,

Instead gazing in water to know

Her own reflection.

Identité

reflets décalés de la Voie lactée,

été de l'enfance

explosion de jeunesse

déplacer des membres minces le long des lignes souriantes

d'un visage insouciant.

Des étoiles dans ses yeux -

Explosions ornementales dans le ciel

Alors qu'elle était assise parmi tout ce qui est bon et

innocent

Comme le soleil brûlait

La bougie de la corruption aspirait à la prendre,

Emballez-la comme une rage instantanée

Frappez la minuterie; tirez sur le cordon.

Mais non, pas celui-ci:

Le temps ne vous le donnera pas.

Construit avec des oreillers d'herbe et des chants de saule,

Des montagnes pour les professeurs et des fleurs pour les

livres,

Elle n'aura jamais de chrome sur verre,

Au lieu de regarder dans l'eau pour le découvrir

Son propre reflet.

Bones

She started smoking again

Feeling bones by finger curls

And the nauseating hunger

For someone to understand

The hard lumps under skin

And the satisfaction of a visible scapula

Under the crushing, suffocating, smothering

Weight of ten pounds

Against the pull of Earth's gravitational force

When the greatest ally against one condition

Becomes the pain of another

Hoping that at the end of this cigarette

She will find the cremated remains

Of her claim to have it all under control

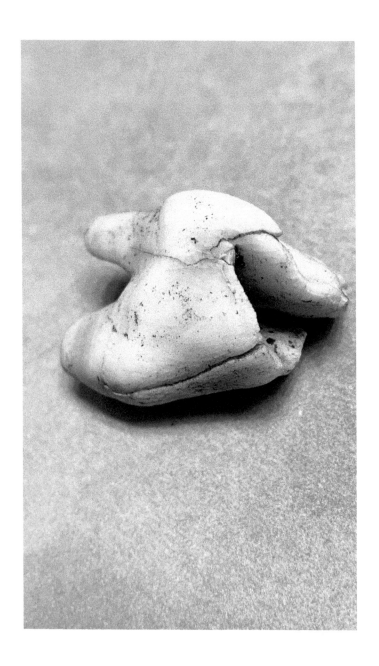

Des os

Elle a recommencé à fumer

Sent les os à travers les boucles des doigts

Et la faim nauséabonde

Pour que quelqu'un comprenne

Bosses dures sous la peau

Et la satisfaction d'une omoplate visible

Sous l'écrasement, la asphyxie, la suffocation

Poids de dix livres

Contre l'attraction de la force gravitationnelle de la Terre

Quand le meilleur allié contre une condition

Devient la douleur d'un autre

En espérant qu'à la fin de cette cigarette

Elle trouvera les restes incinérés

De sa prétention d'avoir tout sous contrôle

A Lesson Never Learned

It came up through the floorboards,

Zyklon B reaching forward through time

Ripping at our throats,

 Forming itself around our nostrils

condensing into blue ice, after being trapped in the cold

of existence.

 This depressive state of humanity

Seeming only to slumber in its death

Released the gas upon itself,

 Using the world as its chamber

Many can claim their innocence

 -besides-

Innocence through ignorance is the best kind

While dictators commence genocidal rampages

 Using ill-earned power to rape a people

 destroy their very creation of a God,

And yet, for those who are suffering:

The strongest woman I (n)ever met

 sat crying at the grand opening of the Holocaust Museum

She surveyed the surrounding young people

Generations too young to remember or know what

 She Survived

Walking through in awe of their own misunderstandings

 She looked back without a single failed memory

Her arm exposed so everyone could see:

 the vining rose tattoo that grew

 out of the numbers that changed her life forever

Une Leçon Jamais Apprise

Il est venu à travers les planches,

Le Zyklon B évolue avec le temps

Déchirer nos gorges

 Formation autour de nos narines

se condensant en glace bleue, après avoir été emprisonné dans le

froid

d'existence.

 Cet état dépressif de l'humanité

Semblant seulement dormir dans sa mort

Libéré le gaz sur lui-même,

 Utilisez le monde comme une pièce

Beaucoup peuvent revendiquer leur innocence

 -outragé-

L'innocence par ignorance est la meilleure

Alors que les dictateurs commencent des saccages génocidaires

 Utiliser un pouvoir mal acquis pour violer un peuple

 détruire leur création même d'un Dieu,

Et pourtant, pour ceux qui souffrent:

La femme la plus forte que j'aie jamais rencontrée

 assis en train de pleurer à l'ouverture du musée de

 l'Holocauste

Elle a étudié la jeunesse environnante

Des générations trop jeunes pour se souvenir ou savoir quoi

 Elle a survécu

ils marchent dans la peur de leurs propres malentendus

 oui elle a regardé en arrière sans un seul souvenir raté

Son bras exposé pour que tout le monde puisse voir:

 Le tatouage de la vigne rose qui a grandi

 parmi les nombres qui ont changé sa vie pour toujours

Small Places

I find God in
 small places:
Whispers of meadows
Choirs of insects

Where old, tired houses
 lay in their foundations
Praying to the saints of
 Nature and Time

He speaks in soft breezes
 And gently destroys
All we created
 With hands that violently
 reap.

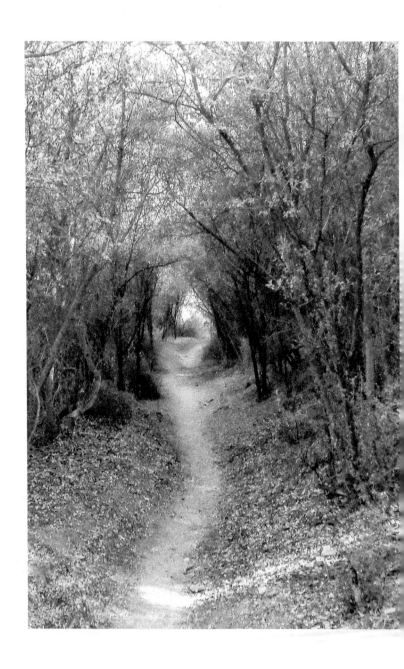

Petits Endroits

Je trouve Dieu en

 petits endroits:

Prairies des prairies

Choeurs d'insectes

Où de vieilles maisons fatiguées

 se prélasser dans leurs fondations

Priez les saints de

 Nature et Temps

Il parle dans une brise tendre

 Et détruisez doucement

Tout ce que nous avons créé

 Avec des mains qui violemment

 recuillier.

The Death Of A Small Town Generation

Thirteen years ago we walked across a church stage

Now, so many of us are dead

Iraq, Afghanistan, or from drug overdoses

[Mostly drug overdoses]

Some of them? farming or fishing accidents – But

Mostly drug overdoses

She called me on the phone

Came down the stairs

Telephone cord like a noose

Did you hear about William?

Did you hear about Carolyn?

Did you hear about Ben?

Did you hear about…

Did you hear about those faces?

You remember all of them.

You know you do.

Each name is a bee

Each death is a stinger

Have you heard about the drug overdoses?

How can I succeed

When my peers won't even see

The same number of birthdays?

Won't even see their children's first days

Of kindergarten as big eyes,

Tiny shoes, and backpacks–

While Widows and Widowers

Left behind – cried dry –

On the other end of the line

I hear my god daughter's mother say

"Another one O.D.' ed"

My feet on the ground

I'm 23, I'm 25, I'm 27, I'm 30

Six dead in six months

Staring back through time

At the faces of the children

We once were

Joking about the adults

They'd never grow up to be

"Who this time?"

I stare into nothingness

I stare into oblivion

I stare into telephone cord nooses

"Just another friend."

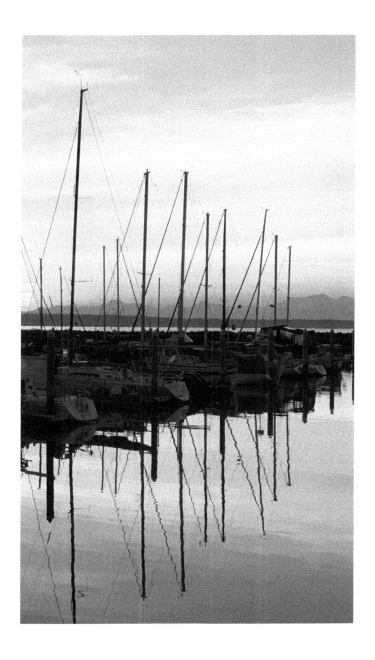

La Mort d'Une Génération de Petites Villes

Il y a treize ans, nous avons traversé une scène d'église

Maintenant, tant d'entre nous sont morts

Irak, Afghanistan ou surdoses de drogue

[Surdosage principalement médicamenteux]

Certains d'entre eux? accidents agricoles ou de pêche - mais

Surdosage principalement de médicaments

Elle m'a appelé au téléphone

Je suis descendu les escaliers

Cordon téléphonique comme un nœud coulant

Avez-vous entendu parler de William?

Avez-vous entendu parler de Carolyn?

Avez-vous entendu parler de Ben?

As tu entendu a propos de…

Avez-vous entendu parler de ces visages?

Vous vous souvenez de tous.

Vous savez que vous faites.

Chaque nom est une abeille

Chaque mort est un dard

Avez-vous entendu parler des surdoses de médicaments?

Comment puis-je réussir

Quand mes pairs ne verront même pas

Le même nombre d'anniversaires?

Je ne verrai même pas les premiers jours de leurs enfants

De la maternelle comme de grands yeux,

Petites chaussures et sacs à dos -

Alors que les veuves et les veufs

Laissé derrière - pleuré sec -

À l'autre bout de la ligne

J'entends la mère de ma filleule dire

«Un autre O.D.' ed»

Mes pieds sur terre

J'ai 23 ans, 25 ans, 27 ans, 30 ans

Six morts en six mois

Regardant à travers le temps

Aux visages des enfants

Nous étions autrefois

Blague sur les adultes

Ils n'auraient jamais grandi pour être

«Qui cette fois?»

Je regarde le néant

Je regarde dans l'oubli

Je regarde les nœuds du cordon téléphonique

«Juste un autre ami.»

In Prayer

Sometimes we wonder

Why we keep calling the same number

When the telephone rings

Until we return the phone to the receiver

Maybe someday

Our Father will answer

And laugh as He says

"I've been waiting for your call all week"

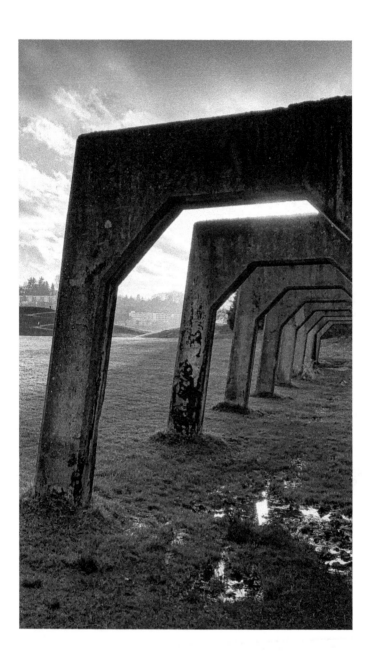

Dans La Prière

Parfois on se demande

Pourquoi nous continuons d'appeler le même numéro

Quand le téléphone sonne

Jusqu'à ce que nous retournions le téléphone au récepteur

Peut-être un jour

Notre Père répondra

Et rire comme il dit

«J'ai attendu votre appel toute la semaine»

Photography

A sudden burst of blinding light:
 An instant flash frozen
- so quick no flower could wilt;
 human attempts to bottle time
 On little strips
then Processed and Transferred
 Colored and Brightened
So later, one may point and say,
 "This is real"

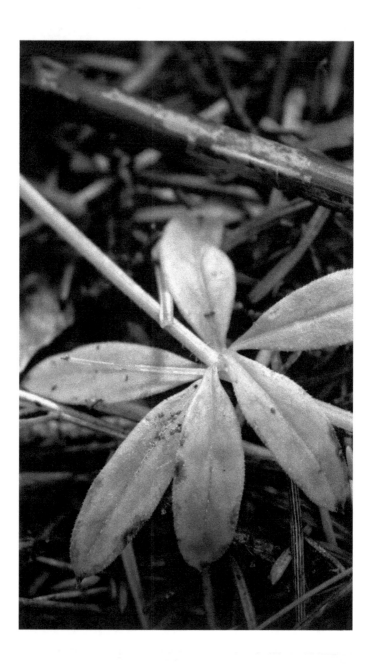

Photographie

Un éclat soudain de lumière aveuglante:

 Un flash instantané figé

- si vite qu'aucune fleur ne peut se faner;

 les humains essaient de mettre le temps en bouteille

 Sur de petites bandes

puis traité et transféré

 Coloré et lumineux

Donc plus tard, nous pouvons pointer et dire,

 «C'est vrai»

Night Fishing

The waves drunkenly slump with slow crashing thuds
Onto the sobering, wearing-thin, patient shore.
Teenagers blast 3 AM
Hip-Hop, Hard-Rock, Smack-Talk
Chattering loudly through gritted teeth and chewing gum
(Attempts to drown their own lives in sound waves)
Tiny glimmers hide from the surface
While solitary barefoot nightwalkers advertise toes
On the transient corner between land and sea

Pêche de Nuit

Les vagues s'effondrent ivre avec de lents bruits sourds
Sur le rivage apaisant, mince et patient.
Les adolescents explosent à 3 heures du matin
«Hip-Hop, Hard-Rock, Smack-Talk»
Chatter fort à travers les dents serrées et le chewing-gum
(Tentatives de noyer leur propre vie dans les ondes sonores)
De minuscules lueurs se cachent de la surface
Comme des marcheurs de nuit solitaires et pieds nus annoncent
leurs orteils
Au coin de la transition entre terre et mer

San Francisco Bay

Such a strange time to live
Digital billboard signs and cities
On the tips of Peninsulas
Outgrown from their boundaries
Companies wealthy off of digital products
Of no tangible substance
Taking money from impoverished masses
Funneling into the still present
Elitist value of objects and materialism
Morphed into the new facade
Of conspicuous consumption wearing
A headdress as it mocks the genocide
Still bleeding from the soil beneath its feet

La Baie de San Francisco

Un moment si étrange à vivre

Panneaux d'affichage numérique et villes

Sur les pointes des péninsules

Au-delà de leurs frontières

Entreprises riches en produits numériques

Sans substance tangible

Prenez l'argent des masses pauvres

Canal dans le toujours présent

Valeur élite des objets et matérialisme

Morphé dans la nouvelle façade

Consommation ostentatoire

la couronne qui rit du génocide

Saignant toujours du sol sous ses pieds

Somewhere you are home

Somewhere you are:
You exist within the eyes that hold you
The emotions that slip deep inside
The holes that make
Bits and pieces a bit too see-through
These broken mirror eyes of love or shame
Your own eyes staring inside
Through the blood that binds
You to this place.

Quelque part où tu es chez toi

Quelque part vous êtes:

Tu existes dans les yeux qui te tiennent

Les émotions qui se glissent profondément à l'intérieur

Les trous qui font

Bits et morceaux un peu trop transparents

Ces yeux miroirs brisés d'amour ou de honte

Tes propres yeux regardent en toi

Par le sang qui lie

Vous dans cet endroit.

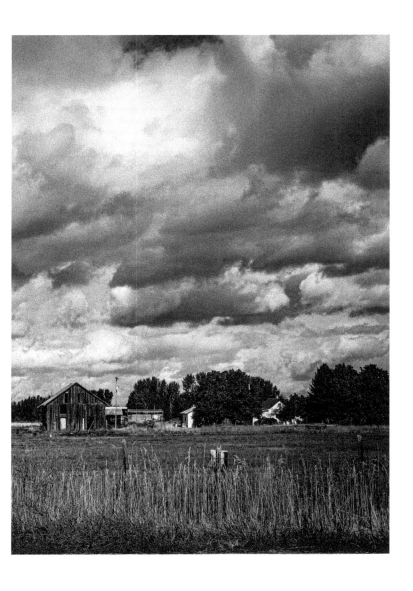

In Gratitude

It is with deepest gratitude that I wish to thank a variety of individuals for their support. In recognition for this book's development during the year 2020 and the past decade, many individuals granted me the patience and assistance necessary for its completion. I recognize that once I release this into the world, these poems will take on lives of their own and I relinquish control of how people may interpret their messages. It is not my place to control how other minds interpret my work.

Many of these poems first appeared in variations on Curensea with the support of its founders, lopotterwrites.com, and on CoffeeHouseWriters with the support of their incredible publishing community. Since these first appearances some changes have been made to improve their quality. I am so grateful for the support of a publisher after experience in self publishing, as this gave me the courage to submit my poetry to other publications, such as Stigma Fighters.

The French translations of each poem were done by the author. These are not intended to be direct translations, rather attempted interpretations that preserve the intended meaning. At this time I expect there to be some errors that require correction in future

editions and humbly welcome feedback.

To Jacob, my life partner, my best friend, and my lighthouse –
thank you for being there through everything.

To Kate Potter, thank you for the time you took to read through
many of these poems and assist in the early stages of collection
curation. It's not every date a Harvard educated collection curator
is willing to provide advice and I am eternally grateful for the
early input you provided.

To my sisters by blood, Rebecca Berg and Jen Ogilvie, no words
can encompass the vast multitude of assistance you both have
provided to me through this process.

To my siblings by fire, Angel & Lee Merritt, Nancy Evelyn Sapp,
Heather Jett, and Naomi Saphra, these poems could have never
been written without the creative forces to which the muses
dance, and I'm fairly certain they've caught St. Andrew's Fire.

To my chosen family, Thomas Potter, Sharon Duncan, Olivia

Ellis, Max Levine, Susan Potter, and Barbara Potter – I am in awe that I got so lucky and that the universe gifted me with you.

My deepest gratitude to Michael Burnett and Amanda LaMonica for their spiritual guidance through our youth. The poems "Small Places" and "In Prayer" would not exist without you both. It brings me great joy seeing you both so happy with spouses that see the gifts to creation you are and growing families that shine with the light up with world with love.

To Christina McLaughlin (Instagram @c.m._painter_), the artist of the cover of a future poetry collection, without our late night writing sessions and childhood dreaming this would not exist. Together we'll make our childhood dreams come true.

To Chris Dunn (Instagram @stellavulpes), it's hard to put into words just how much our friendship means to me. You asked about the poems from high school and I promise they'll make an appearance in a future collection. To anyone reading this, please take a moment to check out his music.

To Will Evans (Album: sleeplessvoid.bandcamp.com), I'm so proud of you. Your solo album during 2020 and this poetry book coincided and the parallel production helped me along. To anyone reading this, please take a moment to listen to his 2020 solo album.

To Kellie Medlin, Joshua Wise, Andrew Krieger, Tess Eisenberger, Matt Stone, Seth McClain, Greg Smith and so many more I am failing to name here: there are no words to express the depth of my gratitude.

Many thanks to the following authors:

Anya Pavelle (@AnyaPavelle on Twitter) for her tireless support and encouragement to make this collection a reality.

Sean Haughton (@SHaughtonAuthor on Twitter) for his constant encouragement, formatting recommendations, and poetry formatting skills.

Alaine Greyson (@AlaineGreyson on Twitter) for her encouragement through the steep learning curve of the publishing process. With her constant encouragement and willingness to act as a role model and mentor to me, I grow every day. I cannot thank her and everyone at Creative James Media enough.

Jordan Pace (@_jordan_pace_ on Twitter) for his support and encouragement during the publishing process while working on his own publishing career and sharing so much of himself through his works. His collections are

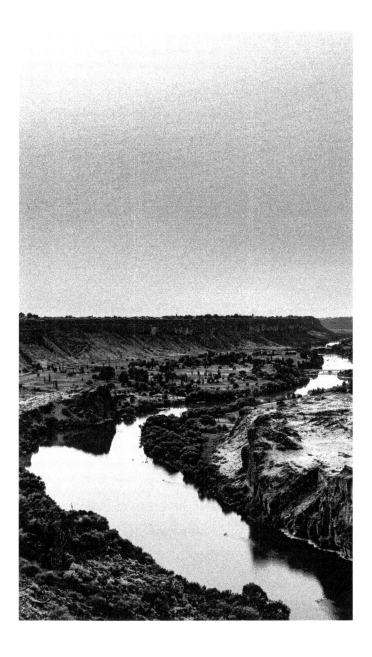

phenomenal, setting an example for poetry's use in discussing difficult topics that should not be kept silent.

Joy Nibbles (@jjnibbles on Twitter) for her support, inspiration, and beautiful talents. She is a role model for narrative poets discussing the topics others would rather hide.

Alyssa Marie Bethancourt (@vulcanelf on Twitter) for her continuous support and recommendation of telling myself that eventually I have to tell myself when to stop.

Darran Handshaw (@Engineer7601 on Twitter) for his support and review of this collection, including recommendations to improve the reading experiences of first responders and medical workers that may deeply connect with the impactful moments mentioned.

Many thanks to the following editors:

Lauralee Martin (@WriteTheFight1 on Twitter), my editor at Coffee House Writers, for her genuine feedback and assistance with my writing projects.

Chet Sandberg (@Chet_Novels on Twitter), a friend and line editor, that took on reading poetry as a favor, stretching his

abilities and growing with me.

And many others within the writing community.

To the following professors, I owe my deepest gratitude for providing me the academic guidance necessary for this book to exist:

To Dr. Katherine Turner, I am so blessed as to have spent time studying poetry under you during my time at Mary Baldwin. As as Oxford educated English Professor, you intimidated me. The greatest compliment I ever received was when you read an early version of "we are nothing, " anonymized, and gave it positive review.

To Dr. Eric Jones, my undergraduate advisor, you encouraged me to keep a healthy balance of the arts in my life while I pursue the sciences. You helped me explore my interests in ethnobotany, plant based pharmaceutical discovery, agriculture, and plant sciences. I am forever grateful for your guidance.

To Dr. Lundy Pentz, the head of the Biology department during my time at Mary Baldwin, I am so grateful for your guidance and teachings on philosophy.

To Dr. Louise Freeman, my research advisor for the majority of my undergraduate education, you opened my mind to a passion for research on drug abuse, consciousness, morality, and the mirror neuron network. I spent the better part of a decade avoiding due to circumstances in my life I failed to communicate. My deepest apologies for being unable to communicate my reasoning for leaving your lab and research.

To the following, though not all are still with us today, it's been the greatest honor to have you by my side as these poems were written and revised over the past decade and some, and assembled here:

Lillian Berg, Rod Potter, Linda Duncan, Sherman Jones, Brandon Bates, Michael Snipas, Thomas Close and many others not named here.

To my parents,

No words can express the gratitude I have for everything you both survived to be here with me. I love you until the end of time.

Thank you for everything.

Lo Potter resides in and regularly explores the Pacific Northwest with family and friends. They connect with the stars, mountains, and ocean, and find laughter even when it's hiding in shadows.

You can read more poetry and short stories on lopotterwrites.com

If you would like a free digital copy of this book, to suggest translation improvements, or to contact the author please send an email to lopotterwrites@gmail.com.

This book allows cited use and unrestricted distribution for education and related causes.

Lightning Source UK Ltd.
Milton Keynes UK
UKHW020812170821
388998UK00014B/1534